Pentagram
Library

14/10/09
purchased

PACKAGING
IDENTITY

INDEX BOOK, SL
Consell de Cent 160 local 3
08015 Barcelona
Phone: +34 93 454 5547
Fax: +34 93 454 8438
E-mail: ib@indexbook.com
URL: www.indexbook.com
Copyright 2009

ISBN: 978-84-96309-42-5

Author: Mito Branding & Design / www.mitodesign.com

The captions and artwork in this book are based on material supplied by
the designers whose work is included. No part of this publication may be
reproduced or transmitted in any form or by any means, electronic or
mechanical, including photocopy, recording or any information storage
and retrieval system, without permission in writing from the copyright owner(s).

While every effort has been made to ensure accuracy, neither Index Book nor the
author under any circumstances accept responsibility for any errors or omissions.

Dami Editorial & Printing Services Co. Ltd.

CHAPTERS

- **To drink**
- **To eat**
- **To listen**
- **For me**
- **For my home**
- **For my job**

TO DRINK

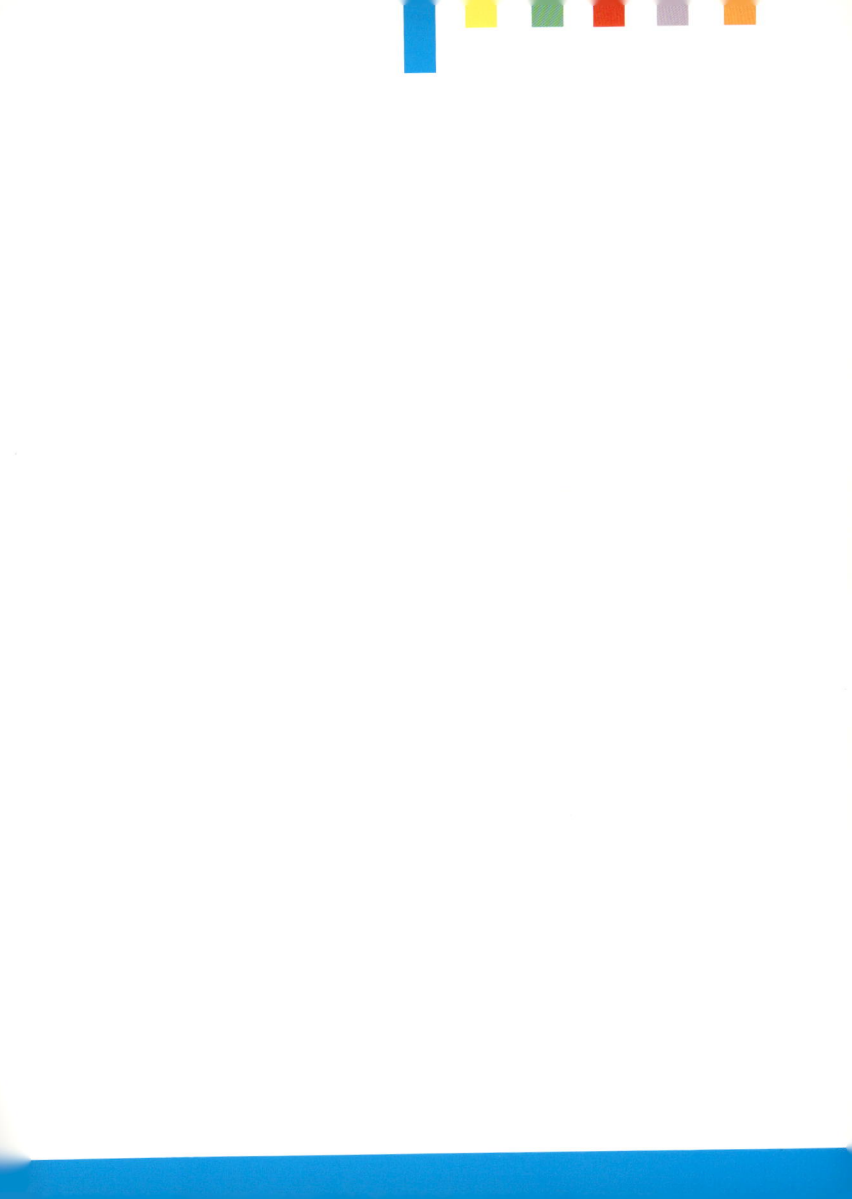

Studio	Aloof Design
Client	U´luvka Vodka

TO DRINK

Studio	Bauer Konzept & Gestaltung
Client	Weinquartier and 3s

TO DRINK

A3 Design | **Studio**
Carolina Blonde | **Client**

Studio	Juha Fiilin
Client	Sanmy

David Mascha | **Studio**
Estrella Damm | **Client**

Studio	Aleksandra Prhal
Client	Voodoo

TO DRINK

Aleksandra Prhal | **Studio**
Belo Weifert | **Client**

| Studio | Pentagram |
| Client | Wistbray |

TO DRINK

| Studio | Pentagram |
| Client | Wistbray |

TO DRINK

Studio	Pentagram
Client	Wistbray

TO DRINK

Studio **Giorgio Davanzo Design**
Client **Senok**

TO DRINK

Studio	Krog - Edi Berk
Client	Klansek

TO DRINK

| Krog - Edi Berk Kis | Studio Client |

| Studio | **LM - Lewis Moberly** |
| Client | **Akvinta Vodka** |

TO DRINK

LM - Lewis Moberly
Mateus Fine Rose Wines

Studio Client

Studio	LM - Lewis Moberly
Client	**Monkey Shoulder**

TO DRINK

| Harcus Design | Studio |
| Jim Beam | Client |

| Studio Client | Image de Marque Marcilla |

TO DRINK

| Estudio Ray | Studio |
| Tres Hermanos Altura | Client |

Studio	Aleksandra Prhal
Client	La Vita

TO DRINK

| **Mary Hutchison Design** | **Studio** |
| **Mocafé Organics** | **Client** |

| Studio | OMB Diseño Grafico |
| Client | Dolce |

TO DRINK

Aleksandra Prhal | **Studio**
Tetra Pak | **Client**

Studio	**OMB Diseño Grafico**
Client	**Dolce**

TO DRINK

Serge Pronin | **Studio**
Cerny VLK | **Client**

Studio	Sonsoles Llorens
Client	Cafés El Magnífico

TO DRINK

Studio	Sonsoles Llorens
Client	Sans & Sans

TO DRINK

Studio	**Sonsoles Llorens**
Client	**Sans & Sans**

TO DRINK

Studio	Ideas Frescas
Client	Estate Coffee

TO DRINK

Ideas Frescas | **Studio**
Eco Café | **Client**

Studio	**Ideas Frescas**
Client	**Alberto Alegría**

TO DRINK

Ideas Frescas | **Studio**
Volcano Roasters | **Client**

Studio	**Estudio Akedis**
Client	**Gabry**

TO DRINK

Harcus Design | **Studio**
Staminade | **Client**

Studio	**Estudio Salvartes Diseño y Publicidad**
Client	**Camara**

TO DRINK

| Jelena Drobac | Studio |
| Elenov | Client |

elenov

VRANAC

Studio	Taxi Studio
Client	Superdrug

Superdrug
Reviving
Effervescent
ONE A DAY – 20 TABLETS

TO DRINK

Tridimage | **Studio**
Frizzante | **Client**

Studio	**Templin Brink Design**
Client	**Archer Farms**

TO DRINK

archer farms

Vitamin A & D

chocolate milk

1% milkfat

An excellent source of protein & calcium

HALF GALLON (1.89 L)

Studio	**Tracy Sabin**
Client	**Sensa**

TO DRINK

Studio	LM - Lewis Moberly
Client	Belu

TO DRINK

| LM - Lewis Moberly Selfridges | Studio Client |

Studio	**Tracy Sabin**
Client	**Slake**

TO DRINK

| Tracy Sabin | Studio |
| Sensa | Client |

Studio Client | **Tridimage Cellier**

TO DRINK

Tridimage	Studio
Cactus	Client

| Studio | Tridimage |
| Client | Jameson |

TO DRINK

**Tridimage Studio
Magno Client**

Studio	Richard Baird Ltd
Client	Hotcan

TO DRINK

Mary Hutchison Design | **Studio**
Teaology | **Client**

Studio	**Raquel Quevedo**
Client	**Herbarium**

TO DRINK

Studio	Raquel Quevedo
Client	Herbarium

TO DRINK

Studio	**Raquel Quevedo**
Client	**Herbarium**

TO DRINK

TO EAT

Studio	Burocratik - Adriano Esteves
Client	Fricar

TO EAT

Studio | **Al Margen Comunicación**
Client | **Antica**

TO EAT

Studio	**Al Margen Comunicación**
Client	**Pórtico de la Villa**

TO EAT

Studio	Studio International - Boris Ljubicic
Client	SMS

TO EAT

Studio	**Codex Design**
Client	**80g**

TO EAT

Studio Olga Shchukina
Client Hayuto

TO EAT

| Estudio Ray | Studio |
| Sabores | Client |

Studio	Dúctil
Client	Panadería Ca'n Paco

TO EAT

Estudiotipo Comunicación Kilina | **Studio Client**

Kilina®

Extremely healthy

Studio	Factor Design
Client	Sponser

TO EAT

LM - Lewis Moberly
Duchy Originals

Studio Client

DUCHY ORIGINALS

OATEN BISCUITS
Stoneground texture. Oven baked taste.

Studio	Hyperakt
Client	Miss Jessie's

TO EAT

| Studio | Infinito Consultores |
| Client | Angel |

TO EAT

Estudio Dizen | **Studio**
Agroindustrias Don Miguel | **Client**

Studio	Karina Terribile
Client	Chicle Hotmail

TO EAT

Infinito Consultores
Fénix - Rellenas

Studio Client

Studio	David Alegria
Client	Buena Bodega

TO EAT

Mary Hutchison Design	Studio
Wow	Client

Studio	**Orange Bcn**
Client	**Escribà**

TO EAT

Studio	Taxi Studio
Client	The Knobbly-Carrot Family

TO EAT

Taxi Studio | **Studio**
Somerfield | **Client**

Studio	**Templin Brink Design**
Client	**Nyne**

TO EAT

| Tracy Sabin | Studio |
| Spanky | Client |

Studio	Taxi Studio
Client	Golden Wonder

TO EAT

Studio	Taxi Studio
Client	Somerfield

Somerfield
BUTTER BASTED STUFFED CHICKEN BREAST JOINT

Butter basted boneless chicken breast, with a pork, sage and onion stuffing

Ready to Roast
simply remove sleeve & film then place in oven for 60 mins
375°F • Gas Mark 5 • 190°C

READY to cook | can be frozen | weight 600g | keep refrigerated use by

Somerfield
GAMMON JOINT WITH APRICOT & ORANGE GLAZE

Easy to carve boneless gammon joint with a fruity apricot and orange sauce

Ready to Roast
simply remove sleeve & film then place in oven for 50 mins
400°F • Gas Mark 6 • 200°C

READY to cook | can be frozen | weight 550g | keep refrigerated use by

TO EAT

Somerfield

PORK

Boneless leg of pork joint with a sachet of bramley apple and west country cider sauce

Recipe guideline

1. ...
2. ...
3. ...
4. S...

Ready to Roast
simply remove sleeve & film then place in oven for 60 mins
375°F • Gas Mark 5 • 190°C

READY to cook | can be frozen | weight 600g | keep refrigerated use by

SERVING SUGGESTION

Somerfield

BASTED BEEF JOINT

A silverside beef joint with added water and glucose syrup

Recipe guidelines:

1. P... si... n... fri...
2. th... ba... se... bro...
3. P... with... and... mix...

Ready to Roast
simply remove sleeve & film then place in oven for 65 mins
400°F • Gas Mark 6 • 200°C

can be frozen | weight 500g | keep refrigerated use by

SERVING SUGGESTION

Studio	Alambre Estudio
Client	Serrats

TO EAT

Studio	**Aleksandra Prhal**
Client	**El Tomato**

TO EAT

2 Creativo | **Studio**
Frutier | **Client**

Studio	2 Creativo
Client	Cooking

татоEAT

**Binomi
Sushi Shop** | **Studio
Client**

Studio	biz-R - Tish England
Client	Holy Cow

TO EAT

Studio	biz-R - Tish England
Client	Clive's

TO EAT

Studio	biz-R - Tish England
Client	Clive's

Clive's
made with love

Quiche.
Organic + Veggie
Brocolli & Stilton

Gluten Free

Handmade in Devon

A perfect combination for quiche.
Made with traditional moist and creamy stilton cheese, complemented with fresh broccoli. Affectionately known as trees and cheese.

Ingredients
Organically produced – fresh milk, broccoli 28%, fresh eggs, stilton 10%, non-hydrogenated palm fat, rice flour, potato flour, corn flour, buckwheat flour, *salt and love.
*approved non-organic Gluten Free

Store according to date label
Do not refreeze once defrosted.
Made in a bakery that handles nuts.

Buckfast Organic Bakery
Devon TQ11 0NR
Tel 01364 642279

Organic Certification UK3

5 031102 000242

www.clivespies.co.uk

Clive's
made with love

Quiche.
Organic + Veggie
Mushroom

Gluten Free

Handmade in Devon

Not a medley, just mushrooms.
A marvellously distinctive flavour nestled in a crisp pastry case made from not one, but four different types of gluten free flour. We're spoiling you!

Ingredients
Organically produced – fresh milk, mushroom 16%, onion 16%, fresh eggs, non-hydrogenated palm fat, rice flour, potato flour, corn flour, non-hydrogenated vegetable margarine sunflower oil, palm oil, coconut oil, water, carrot juice, emulsifier *soya lecithin, lemon juice, *natural flavouring) buckwheat flour, *salt and love.
*approved non-organic Gluten Free

Buckfast Organic Bakery
Devon TQ11 0NR
Tel 01364 642279

Store according to date label
Do not refreeze once defrosted.
Made in a bakery that handles nuts.

Organic Certification UK3

5 031102 000235

www.clivespies.co.uk

TO EAT

Studio	Studio International - Boris Ljubicic
Client	SMS

TO EAT

džem od suhe marelice
minimalno 85% voća

džem od suhe šljive
minimalno 87% voća

džem od miješanog mediteranskog voća
minimalno 87% voća

Studio	Studio International - Boris Ljubicic
Client	SMS

TO EAT

Studio	Studio International - Boris Ljubicic
Client	SMS

TO EAT

| Studio | Carmela "Lala" Bower |
| Client | Brand Castle (In the Mix Cookie Company) |

TO EAT

CARAMEL APPLE PIE COOKIE MIX
with caramel icing

BANANA WALNUT COOKIE MIX
with cream cheese icing

Studio	Client
Consuma	Chaca-Otur

TO EAT

Arroz con Leche

yotur

de Otur, naturalmente!

- Elaborado con Auténtica
 LECHE ASTURIANA

100% ARTESANO
100% NATURAL

Composición:

150 grs

Elaborado por:
CHACA-OTUR Sociedad Cooperativa.
Otur. Asturias

Consumir preferentemente antes de:
VER TAPA

Yogurt Artesano

yotur

de Otur, naturalmente!

- Elaborado con Auténtica
 LECHE ASTURIANA

100% ARTESANO
100% NATURAL

Composición:

150 grs

Elaborado por:
CHACA-OTUR Sociedad Cooperativa.
Otur. Asturias

Consumir preferentemente antes de:
VER TAPA

| Studio | **Estudio Akedis** |
| Client | **Mallorca** |

TO EAT

Giorgio Davanzo Design
Cibo Naturals

Studio
Client

Studio	Harcus Design
Client	Lynwood Preserves

LYNWOOD

Blood Orange Marmalade

TO EAT

Studio	**Infinito Consultores**
Client	**To Go**

TO EAT

Studio	Israel Chavira
Client	Flaxcallan

TO EAT

**Estudio Dizen
Vita Mediterránea**

**Studio
Client**

Studio	Image de Marque
Client	Dulcinea

TO EAT

| Studio Client | Image de Marque Bollycao Dokyo |

TO EAT

| Kinetic | Studio |
| Jubes | Client |

Studio	Jelena Drobac
Client	Banim

TO EAT

banim

mazza
topljeni sir za mazanje

banim

Krem sir
min. 50 % MSM 500g

banim

dijet sir
do 10% MSM 500g

Studio	Jose Luis Guerrero Garcia
Client	Merce

TO EAT

**Marcelle Pinna
Casa & Video**

**Studio
Client**

| Studio | LM - Lewis Moberly |
| Client | Panini |

TO EAT

LM - Lewis Moberly
Waitrose

Studio Client

Waitrose
SWISS PLAIN
CHOCOLATE
WITH AMARETTI

Waitrose
SWISS PLAIN
CHOCOLATE
WITH COFFEE

Studio	LM - Lewis Moberly
Client	Waitrose

TO EAT

A DRIZZLE OF **TRUFFLE** INFUSED EXTRA VIRGIN OLIVE OIL

A DASH OF **SHERRY VINEGAR**

A GENEROUS HELPING OF GRILLED SUNDRIED **TOMATOES** IN OLIVE OIL

A GENEROUS HELPING OF **GRILLED ARTICHOKES** IN OLIVE OIL

A SCOOP OF VIALONE NANO **RISOTTO** RICE

Page 150-151

Studio	**LM - Lewis Moberly**
Client	**Waitrose**

TO EAT

Studio	LM - Lewis Moberly
Client	Waitrose

VACHERIN MONT D'OR
SPRUCE WOOD INFUSED, ORANGEY PINK RIND ENCASING A SOFT, PALE CREAMY PASTE
UNPASTEURISED COW'S MILK
PRODUCT OF FRANCE

APPLEBY'S CHESHIRE
DELICATE, GRASSY TONES WITH A PLEASANT, SHARP, FRESH TASTE AND FIRM, FLAKY TEXTURE
UNPASTEURISED COW'S MILK
PRODUCT OF ENGLAND

CAVE AGED GRUYERE
FRUIT, SPICE AND NUTS WITH A CARAMEL SWEETNESS AND WHITE WINE AROMA
UNPASTEURISED COW'S MILK
PRODUCT OF SWITZERLAND

MOUNTAIN GORGONZOLA
FULLY MATURED TINGLY, PIQUANT TASTE AND RICH, CREAMY TEXTURE MARBLED WITH BLUE VEINS
PASTEURISED COW'S MILK
PRODUCT OF ITALY

TO EAT

ENGLISH MUSTARD WHOLEGRAIN MUSTARD FRENCH MUSTARD

APPLE SAUCE MINT JELLY TARTARE SAUCE REDCURRANT JELLY

| Studio | LM - Lewis Moberly |
| Client | Tamarind |

TO EAT

	LM - Lewis Moberly	Studio
	Selfridges	Client

Studio	Marnich Associates
Client	La Sirena

TO EAT

ÂPETITS
20 DELICADOS
MINI HOJALDRES CREMOSOS

Espinaca & Ricotta · Roquefort · Langostinos · Pescado

16-18 minutos horno Contiene 20 piezas / 218g

ÂPETITS
6 BOCADOS GOURMET
SALMÓN, VIEIRA Y CAMARÓN

Dos bocados de salmón y salsa de cítricos. Dos bocados de camarones y vinagreta. Dos bocados de vieira con esencia de trufa.

Sólo descongelar Contiene 6 cucharas de 10g / 60g

Studio	Templin Brink Design
Client	Archer Farms

TO EAT

Studio	Client
Templin Brink Design	**Archer Farms**

TO EAT

Studio	Tracy Sabin
Client	Seafarer Baking Company

TO EAT

Springerle

Seafarer Baking Company
Carlsbad, California

Frohe Weihnachten 2002

Studio | **Jorge Jorge Designer by SKA**
Client | **Manuel Carvalho S.A.**

ultrafrio
ultracongelados

é **ultra** fresco

Na **Ultra-Frio** ficamos ainda mais frescos.

Peso Líquido **400 g**

TO EAT

**WR Comunicação Mkt Design
Socil Guyomarc´h** | **Studio Client**

Studio	Raquel Quevedo
Client	Mackarrá

TO EAT

TO LISTEN

Studio	Voilà Publicidad
Client	Thisgrace

TO LISTEN

Studio	Alambre Estudio
Client	Almudena Ortega & Josu Okiñena

TO LISTEN

Aita Donostia

Ahots eta pianorako musika (III)
Música para voz y piano (III)

Almudena Ortega
Josu Okiñena

| Studio | **Alambre Estudio** |
| Client | **Dhemenbook** |

TO LISTEN

Alambre Estudio NB | **Studio Client**

Studio	Studio International - Boris Ljubicic
Client	MDC

TO LISTEN

Studio International - Boris Ljubicic
Croatian National Tourist Board

Studio
Client

| Studio | **Brand Attack** |
| Client | **Barrio Negro** |

TO LISTEN

Brand Attack | **Studio**
K Industria | **Client**

Studio	**Richard Chartier Design**
Client	**DSP (Italy)**

TO LISTEN

Page 182-183

Studio	**Magma Brand Design**
Client	**Golden Move**

TO LISTEN

golden move

MUSIC BY SHAHROKH SOUNDOFK
PRESENTED BY FINEST/MAGMA & PARTNERS

FM

golden move

MUSIC BY SHAHROKH SOUNDOFK
PRESENTED BY FINEST/MAGMA & PARTNERS

GOLDEN MOVE
SHAHROKH SOUNDOFK

1. EASY LIVIN / 5:30
2. MOVEMENT / 5:06
3. SING A LA / 7:07
4. TRIP TO PARADISE / 6:47
5. ELECTRIC ROOT / 5:46
6. BLUE MOOD / 7:33

ALL TRACKS PRODUCED BY SHAHROKH DINI UND ANDREAS KÖHLER AT COMTUNE STUDIOS. VOCALS ON EASY LIVIN BY LENI TOLE. EASY LIVIN MIXED AND MASTERED BY ANDY SCHÖPFF. ALL TRACKS MASTERED BY ANDY SCHÖPFF. SPECIAL THANKS TO RAJI. TRACKS 1-6 ORIGINALLY RECORDED FOR WWW.BECKER.DE/MOBILE.
© SHAHROKH SOUNDOFK, FINEST/MAGMA & PARTNERS 2005

WWW.FINESTMAGMA.COM

| Studio | Image Creation |
| Client | Underground |

TO LISTEN

Laura Varsky
Surco / Universal Music

Studio
Client

Studio	**Laura Varsky**
Client	**Surco / Universal Music**

TO LISTEN

BUSCA TU SOL,
BUSCA TU SUEÑO,
TU PROPIO CAMINO
SERÁ EL VERDADERO

COMO UNA PINTURA NOS VAMOS BORRANDO

ACÁ NOMÁS SE SALUDAN
LA LUNA Y EL SOL

Studio	**Laura Varsky**
Client	**Ojas**

TO LISTEN

Laura Varsky | **Studio**
Guillermina | **Client**

Studio | **Laura Varsky**
Client | **Sueños Innatos**

TO LISTEN

Laura Varsky
Surco / Universal Music | **Studio Client**

Studio	Tea Time Studio
Client	Caipirinha Music

TO LISTEN

Page 194-195

Studio	Tea Time Studio
Client	Caipirinha Music

TO LISTEN

Page 196-197

| Studio | Tea Time Studio |
| Client | Caipirinha Music |

TO LISTEN

cineplexx

Studio	Tea Time Studio
Client	Zigzag

TO LISTEN

| Studio | Raquel Quevedo |
| Client | Wild Song |

TO LISTEN

wild song

Page 202-203

Studio	**Magma Brand Design**
Client	AKG

TO LISTEN

AKG

K 324 P
CHROME
HIGH-PERFORMANCE EARPHONES
ÉCOUTEURS HAUTE PERFORMANCE

AKG

K 412 P
FOLDABLE MINI HEADPHONES
MINI CASQUE PLIABLE

FOR ME

Studio	Aloof Design
Client	Twentytwentyone

Pure linen teatowel
designed by Lucienne Day

FOR ME

| Studio | 310k |
| Client | Hempworks |

FOR ME

Templin Brink Design | Studio
High Sierra | Client

Studio	**Ana Roncha**
Client	Salsa Jeans

FOR ME

| Ana Roncha | Studio |
| Deed | Client |

| Studio | Agencia Luz Verde |
| Client | Fimpex |

FOR ME

Image de Marque Scalextric | **Studio Client**

| Studio | **Mission Design** |
| Client | **Norheim** |

FOR ME

Studio	**Mission Design**
Client	**Ulvang-Ull**

FOR ME

Studio **Templin Brink Design**
Client **Merona**

FOR ME

Studio	Archrival - Joel Kreutzer
Client	SPA Aquatique

FOR ME

Studio	Archrival - Joel Kreutzer
Client	La fleur Organique

FOR ME

Magma Brand Design | **Studio**
Eubiona | **Client**

Studio Client	Image de Marque
	Maja

FOR ME

Designo Design Peccatum | **Studio Client**

Studio	**Bijoux Indiscrets - Elsa Viegas**
Client	**Poême**

FOR ME

Studio	Laranja Design
Client	EFX

FOR ME

Studio	**Harcus Design**
Client	**Ethos**

FOR ME

Studio	**Harcus Design**
Client	**David Jones**

FOR ME

**Harcus Design
Trelivings Tuberose**

**Studio
Client**

Studio	**Harcus Design**
Client	**Earthly Possessions**

FOR ME

Studio	**Alan The Gallant**
Client	**FHI**

FOR ME

Kinetic Refill Bottle | Studio Client

Studio	Alan The Gallant
Client	Ame de la Suisse

FOR ME

Studio Salvador García-Ripoll & Manuel Vázquez
Client La Cabane

FOR ME

Studio	**Studio Creamcrackers**
Client	**O Boticário**

FOR ME

Tridimage | **Studio**
Full Sun | **Client**

Page 244-245

| **Studio** | **Ana Roncha** |
| **Client** | **Salsa Jeans** |

FOR ME

Salsa Jeans
FITS MY LIFE

GENUINE BRAND
REGISTERED TRADEMARK SINCE 1994

THIS IS AN ORIGINAL
PREMIUM QUALITY

Studio	WR Comunicação Mkt Design
Client	3M

FOR ME

Studio	WR Comunicação Mkt Design
Client	Bons Sonhos

FOR ME

**Raquel Quevedo
Mediterraneum** | **Studio
Client**

Studio **Raquel Quevedo**
Client **Rosella**

FOR ME

Raquel Quevedo | **Studio**
Témásté | **Client**

Studio | **Jose Luis Guerrero Garcia**
Client | **Arte y Parte - Omnilife**

FOR ME

Harcus Design | **Studio**
Arinya Accessories | **Client**

| Studio | LM - Lewis Moberly |
| Client | Girls Girls Girls |

FOR ME

FOR MY HOME

| Studio | Factor Design |
| Client | Gardena |

FOR MY HOME

Art. 1910

GARDENA®

D Impulsspritze
GB Adjustable Gun
NL Spuitpistool
E Pistola de riego
P Pistola pulverdora
DK Blindtekstpistol

2 in 1

BASIC

D Stufenlose Mengenregulierung
GB Infinite adjustable spray pattern
NL Waterdoorvoer traploos instelbaar

E Regulación de la forma del chorro de agua
P Jacto de água totalmente ajustável
DK Jeg er blindtekst. Fra lads blindtekst føds

Studio	Giorgio Davanzo Design
Client	Cranium

FOR MY HOME

Image Creation | **Studio**
Pocoyo | **Client**

Studio	WR Comunicação Mkt Design
Client	3M

FOR MY HOME

Regina Puig Jané | **Studio Client**

Studio	Regina Puig
Client	Jané

FOR MY HOME

Studio	WR Comunicação Mkt Design
Client	3M

FOR MY HOME

Binomi | **Studio**
Justor | **Client**

Studio	**Unmarked Vehicle**
Client	**Unmarked Vehicle**

FOR MY HOME

Raquel Quevedo | **Studio**
Xocolatl | **Client**

XOCOLATL

el roce me enciende

Studio	Tracy Sabin
Client	Adra

FOR MY HOME

Studio	**A3 Design**
Client	**A3 Design**

FOR MY HOME

Studio	**Magma Brand Design**
Client	**DM-Drogerie Markt**

FOR MY HOME

310k Goods | Studio Client

| Studio | Studio International - Boris Ljubicic |
| Client | Labud |

FOR MY HOME

| Studio | Studio International - Boris Ljubicic |
| Client | Labud |

FOR MY HOME

Tridimage | **Studio**
Clorox | **Client**

Studio	**Image Creation**
Client	**Destiny Home**

FOR MY HOME

Mission Design | **Studio**
Jotun | **Client**

FOR MY JOB

Studio Client | **Binomi Weber**

FOR MY JOB

Binomi | **Studio**
Binomi | **Client**

UN REGALO QUE DA LA TALLA. EL SURREALISMO ES UN MOVIMIENTO CREATIVO QUE INTENTA SOBREPASAR LO REAL IMPULSANDO CON AUTOMATISMO PSÍQUICO LO IMAGINARIO Y LO IRRACIONAL. SI ENCIMA LO PUEDES LLEVAR PUESTO Y LUCIRLO POR BENIDORM, QUÉ MÁS SE PUEDE PEDIR... FELICES FIESTAS, AMIGOS.

binomi diseño gráfico

Studio	Binomi
Client	Binomi

SE ACABARON LOS REGALOS CHAPADOS A LA ANTIGUA

Estas Navidades queremos obsequiaros con un detalle que sorprenderá a todo el mundo, a los que chapurrean idiomas, a los que chapotean en la bañera, a los más chaparros, a los que sólo comen chapata, incluso a los que no pegan ni chapa... ¡Chapeau a todos por vuestro apoyo y colaboración! Felices Fiestas.

binomi diseño gráfico

FOR MY JOB

Studio	**Benedita Feijó & Michael Andersen**
Client	**Absoluty**

FOR MY JOB

| Estudi Fosch | Studio |
| Estudi Fosch | Client |

Studio	Tea Time Studio
Client	Expo Seul Design Made

FOR MY JOB

Page 292-293

Studio	**Alambre Estudio**
Client	**Alambre Estudio**

FOR MY JOB

Studio | **Binomi**
Client | **Saint-Gobain Calmar**

FOR MY JOB

Studio	Johana Ertl
Client	**SPE Networks Latin America**

FOR MY JOB

Studio Templin Brink Design
Client American Eagle

FOR MY JOB

| Studio | Adriano Fidalgo |
| Client | Cantão |

FOR MY JOB

Studio	Paula Mello
Client	Lívia Canuto

FOR MY JOB

Rua Design | **Studio**
Rua Design | **Client**

| Studio | **Mission Design** |
| Client | **Damian Heinisch** |

FOR MY JOB

Studio	**Mission Design**
Client	Pal Laukli

FOR MY JOB

When you press the shutter button down

PÅL LAUKLI >> PORTFOLIO

Studio	Satellites Mistaken for Stars
Client	Emissions

FOR MY JOB

| Studio | **Satellites Mistaken for Stars** |
| Client | **Places to go, people to see, things to do - Zine** |

FOR MY JOB

Struggling with anger problems or psychic pain?

places go, people to see, th to do

| Studio | **Strichpunkt Design** |
| Client | **DTP** |

FOR MY JOB

Studio	Taxi Studio
Client	Science Museum

science museum | serious on the outside...

FOR MY JOB

DIRECTORY

2 Creativo - 113, 114
www.2creativo.net

310k - 210, 277
www.310k.nl

A3 Design - 011, 274, 275
www.athreedesign.com

Adriano Fidalgo - 302, 303
www.urbangrafiks.com

Agencia Luz Verde - 214
www.agencialuzverde.com.ar

Alambre Estudio - 110, 111, 174, 175-177, 294, 295
www.alambre.net

Alan The Gallant - 238, 240, 241
www.alanthegallant.com

Aleksandra Prhal - 014, 015, 032, 035, 112
www.aleksandra.hitart.com

Al Margen Comunicación - 078, 079, 080, 081
www.almargen.com

Aloof Design - 008, 009, 208, 209
www.aloofdesign.com

Ana Roncha - 212, 213, 246, 247
www.anaroncha.com

Archrival - Joel Kreutzer - 222, 223, 224
www.archrival.com

Bauer Konzept & Gestaltung - 010
www.erwinbauer.com

Benedita Feijó & Michael Andersen - 290
www.interactcreative.com

Bijoux Indiscrets - Elsa Viegas - 228, 229
www.bijouxindiscrets.com

Binomi - 115, 269, 286, 287, 288, 289, 296, 297
www.binomi.es

biz-R - Tish England - 116, 117, 118, 119, 120, 121
www.biz-r.co.uk

Brand Attack - 180, 181
www.brandattack.net

Burocratik - Adriano Esteves - 076, 077
www.burocratik.com

Carmela "Lala" Bower - 128, 129

Codex Design - 084, 085
www.codex.pt

Consuma - 130, 131
www.consuma.es

David Alegria - 98
www.alegria.es

David Mascha - 013
www.davidmascha.com

Designo Design - 227
www.designodesign.com.br

Dúctil - 088
www.ductilct.com

Estudi Fosch - 291
www.estudifosch.com

Estudio Akedis - 048, 132

Estudio Dizen - 095, 139
www.dizen.com.ar

Estudio Ray - 031, 087
www.estudioray.com

Estudio Salvartes Diseño y Publicidad - 050
www.salvartes.com

Estudiotipo Comunicación - 089
www.estudiotipo.es

Factor Design - 090, 260, 261
www.factordesign.com

Giorgio Davanzo Design - 022, 023, 133, 262
www.davanzodesign.com

Harcus Design - 029, 049, 134-135, 232-237, 255
www.harcus.com.au

Hyperakt - 092, 093
www.hyperakt.com

Ideas Frescas - 044, 045, 046, 047
www.ideas-frescas.com

Image Creation - 186, 263, 282
www.imagecreation.eu

Image de Marque - 030, 140, 141, 142, 215, 226
www.imagedemarque.es

Infinito Consultores - 094, 097, 136, 137

Israel Chavira - 138
www.israelchavira.com

Jelena Drobac - 051, 144, 145
www.d-ideashop.com

Johana Ertl - 298, 299

Jorge Jorge Designer by SKA - 166
www.jorgejorge.com

Jose Luis Guerrero Garcia - 146, 254
www.cartolacriativa.com.br

Juha Fiilin - 012
www.fiilin.com

Karina Terribile - 096
www.karinaterrible.com.ar

Kinetic - 143, 239
www.kinetic.com.sg

Krog - Edi Berk - 024, 025
www.ediberk.com

Laranja Design - 230, 231
www.laranjadesign.com.br

Laura Varsky - 187, 188, 189, 190, 191, 192, 193
www.lauravarsky.com.ar

LM - 026-028, 058-059, 091, 148-157, 256-257
www.lewismoberly.com

Magma Brand Design - 184-185, 204-205, 225, 276
www.magmabranddesign.de

Marcelle Pinna - 147

Marnich Associates - 158, 159
www.marnich.com

Mary Hutchison Design - 033, 069, 99
www.maryhutchisondesign.com

Mission Design - 216-219, 283, 306–309
www.mission.no

Olga Shchukina - 086

OMB Diseño Grafico - 034, 036
www.oscarmarine.com

Orange Bcn - 100, 101
www.orangebcn.com

Paula Mello - 304
www.liviacanuto.com

Pentagram - 016, 017, 018, 019, 020, 021
www.pentagram.com

R.Quevedo - 068-073, 168-169, 202-203, 251-253, 271
www.raquelquevedo.com

Regina Puig - 265, 266, 267
www.reginapuig.com

Richard Baird Ltd - 066
www.richardbaird.co.uk

Richard Chartier Design - 182, 183
www.richardchartierdesign.com

Rua Design - 305
www.ruadesign.net

S.García-Ripoll & Manuel Vázquez - 242, 243
www.salvartes.com

Satellites Mistaken for Stars - 310, 311, 312, 313
www.satellitesmistakenforstars.com

Serge Pronin - 037
www.prodesign.ru

Sonsoles Llorens - 038, 039, 040, 041, 042, 043
www.sonsoles.com

Strichpunkt Design - 314, 315
www.strichpunkt-design.de

Studio Creamcrackers - 244
www.creamcrackers.com.br

Studio International - Boris Ljubicic - 082, 083, 122-127, 178-179, 278-280
www.studio-international.com

Taxi Studio - 052, 102, 103, 106-109, 316, 317
www.taxistudio.co.uk

Tea Time Studio - 194-201, 292, 293
www.teatimestudio.com

Templin Brink Design - 054, 055, 104, 160-163, 211, 220, 221, 300, 301
www.tomorrowpartners.com

Tracy Sabin - 056, 057, 060, 061, 105, 164, 165, 272, 273
www.tracysabin.com

Tridimage - 053, 062-065, 067, 245, 281
www.tridimage.com

Unmarked Vehicle - 270
www.unmarkedvehicle.net

Voilà Publicidad - 172, 173

WR Comunicação Mkt Design - 167, 248, 249, 250, 264, 268
www.wrcom.com.br